Primäre
Primary (German Edition)

Elizabeth Gauthier

1st Edition
Text © 2013 Elizabeth Gauthier
All rights reserved. No part of this book may be reproduced or copied in any way without written consent of the publisher other than short quotations for articles or review.
Translation by OneHourTranslation

For information about permissions
please write Gauthier Publications at:

Gauthier Publications
P.O. Box 806241
St Clair Shores, MI 48080
Attention: Permissions Department

Hungry Goat Press is an imprint of Gauthier Publications
www.EATaBOOK.com

Gelb

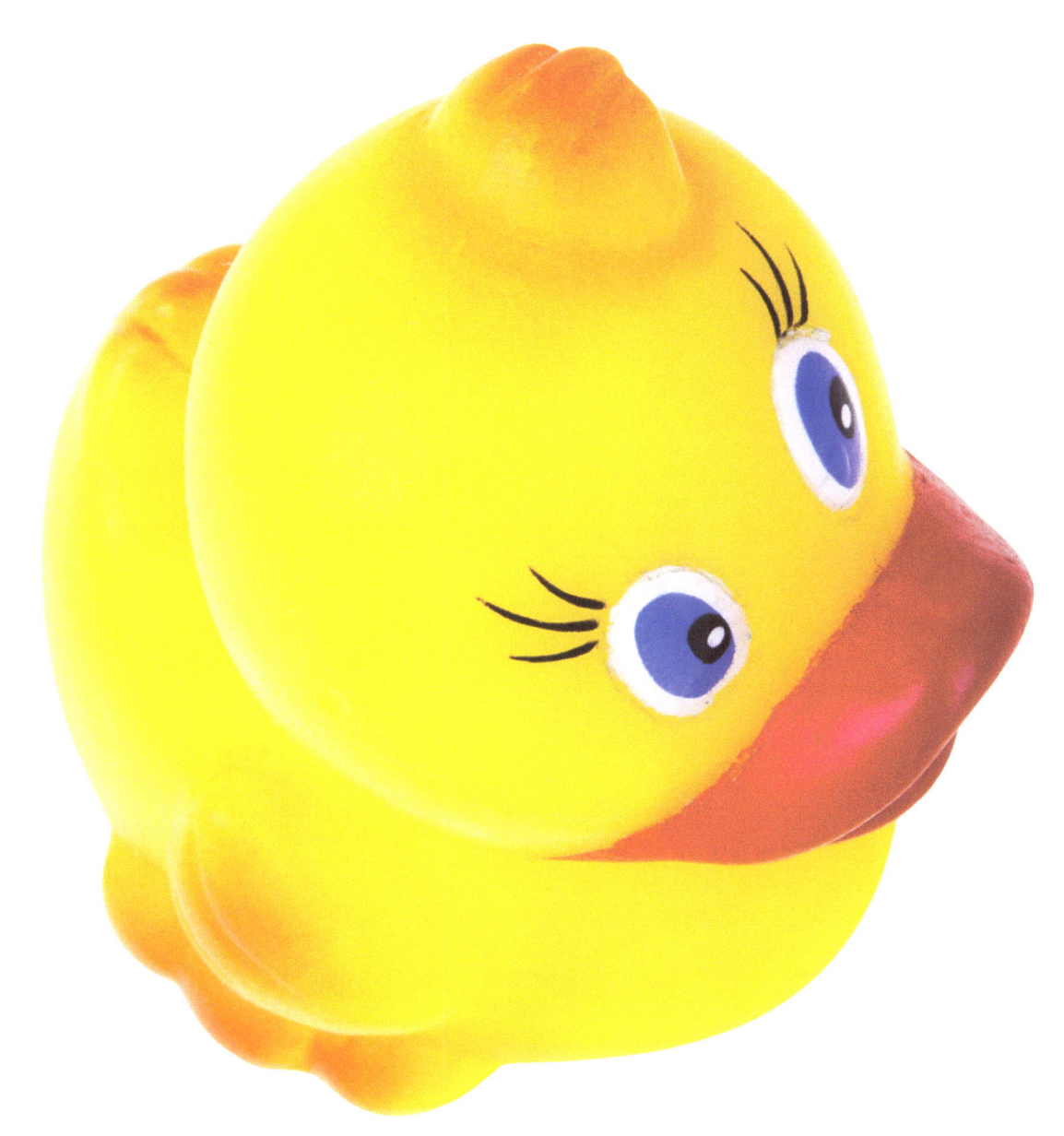

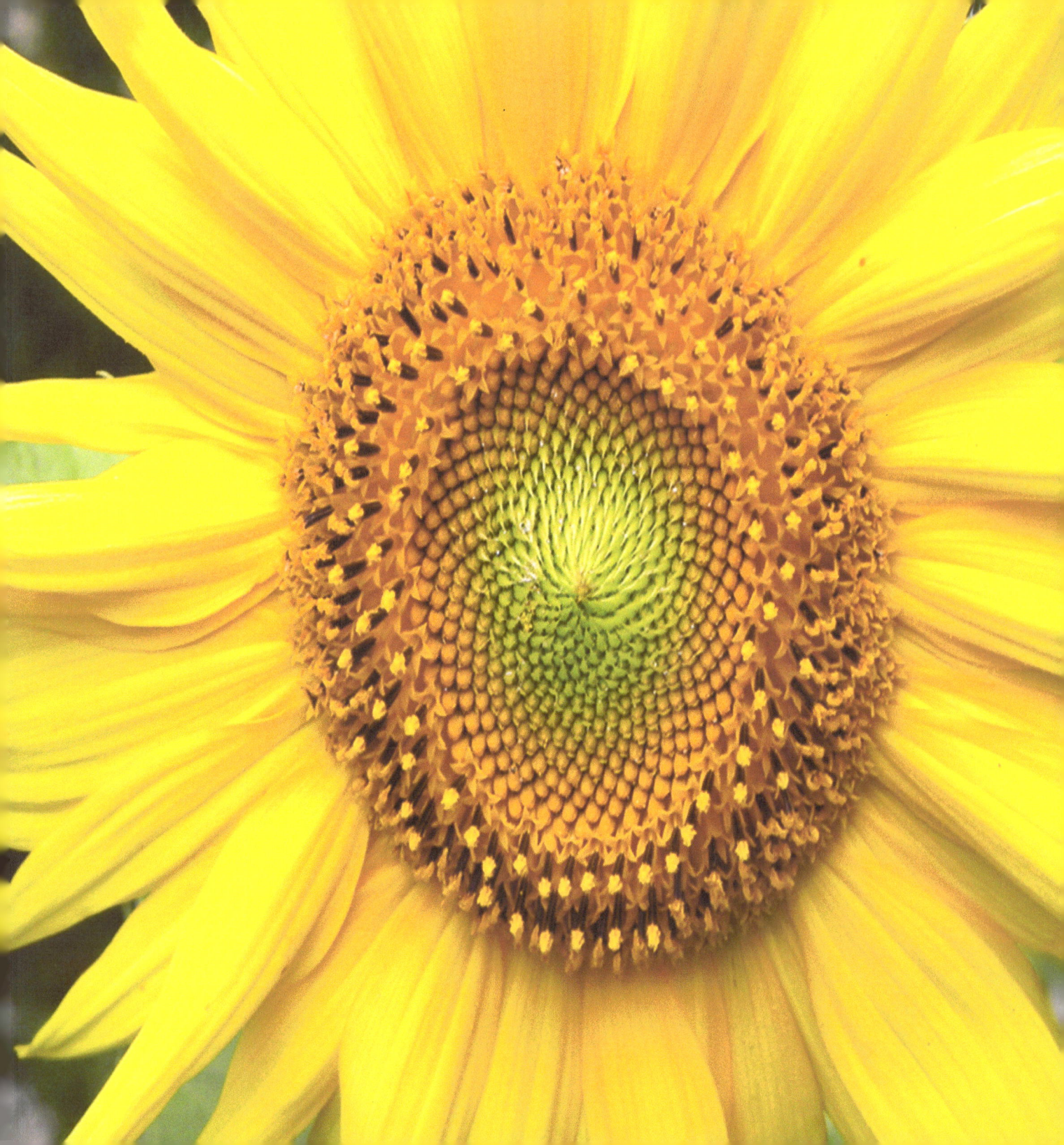

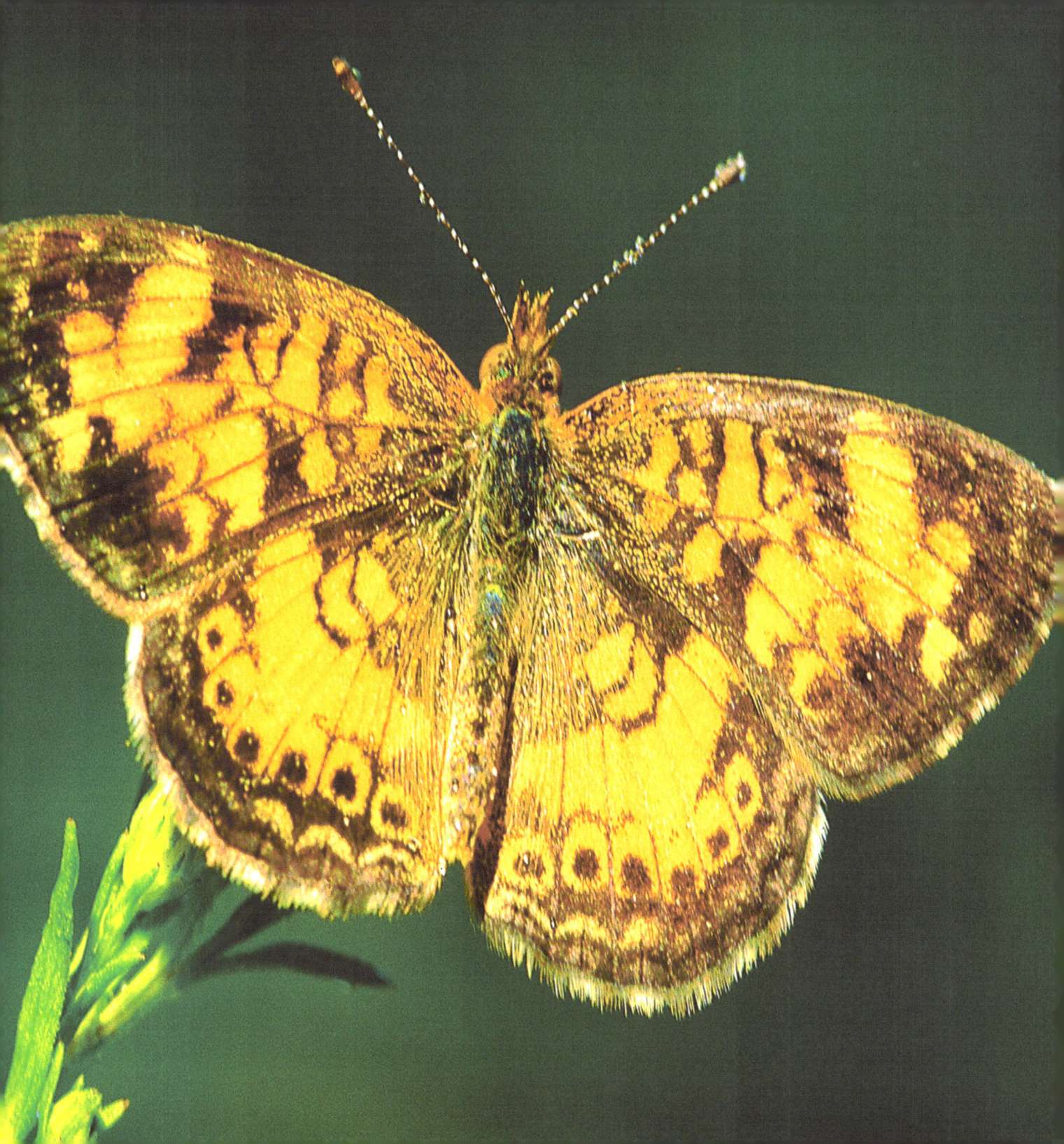

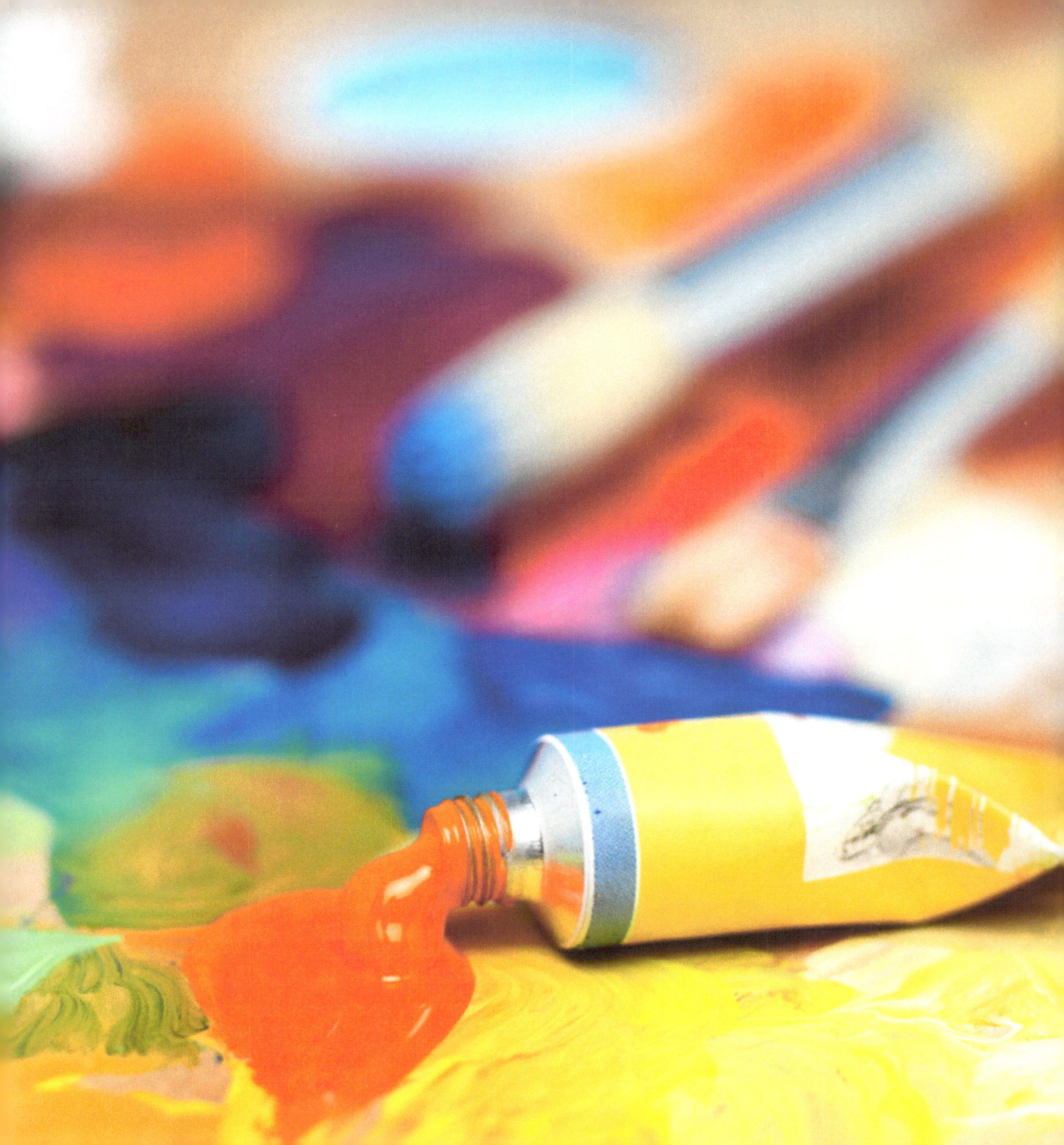

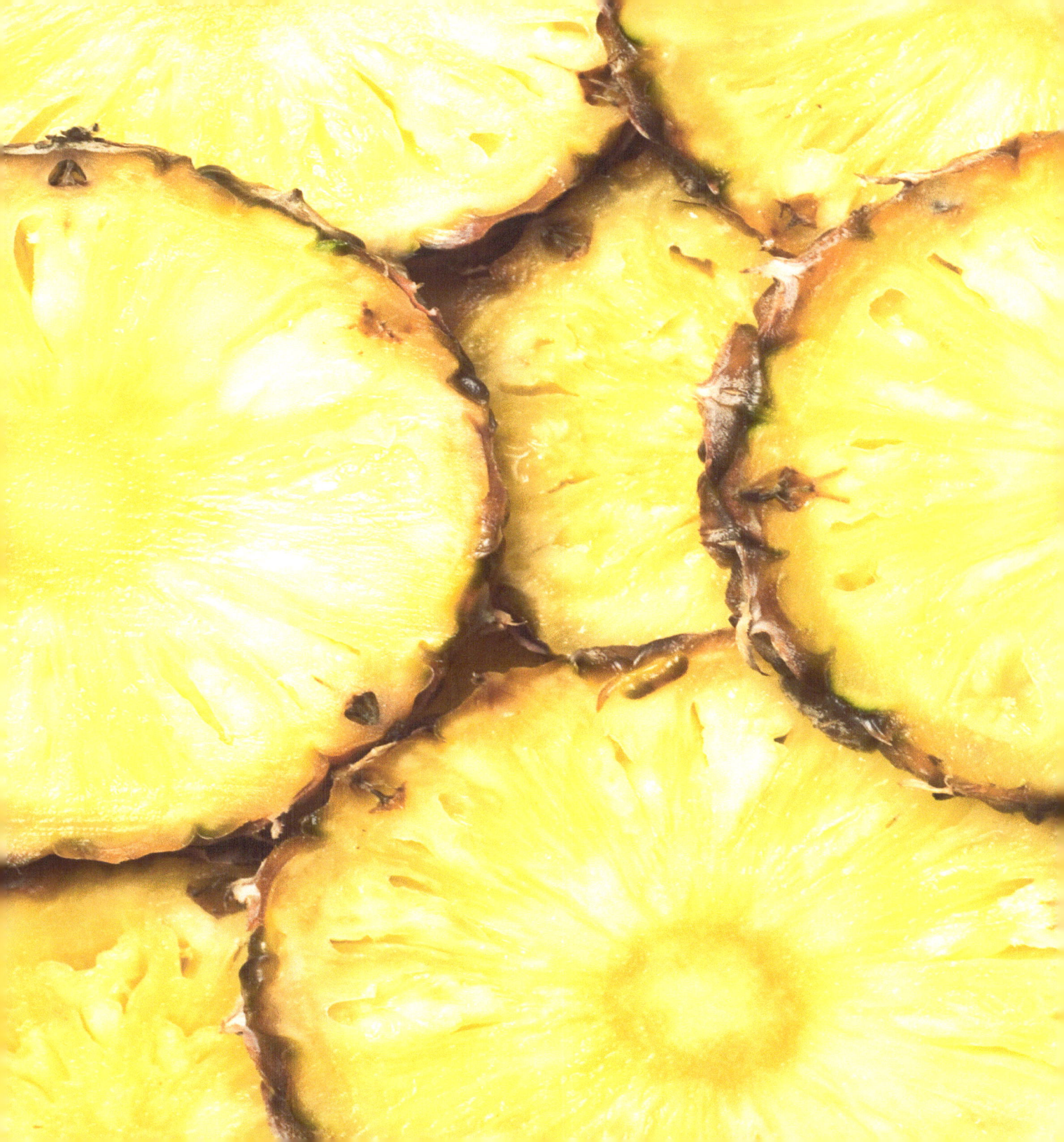

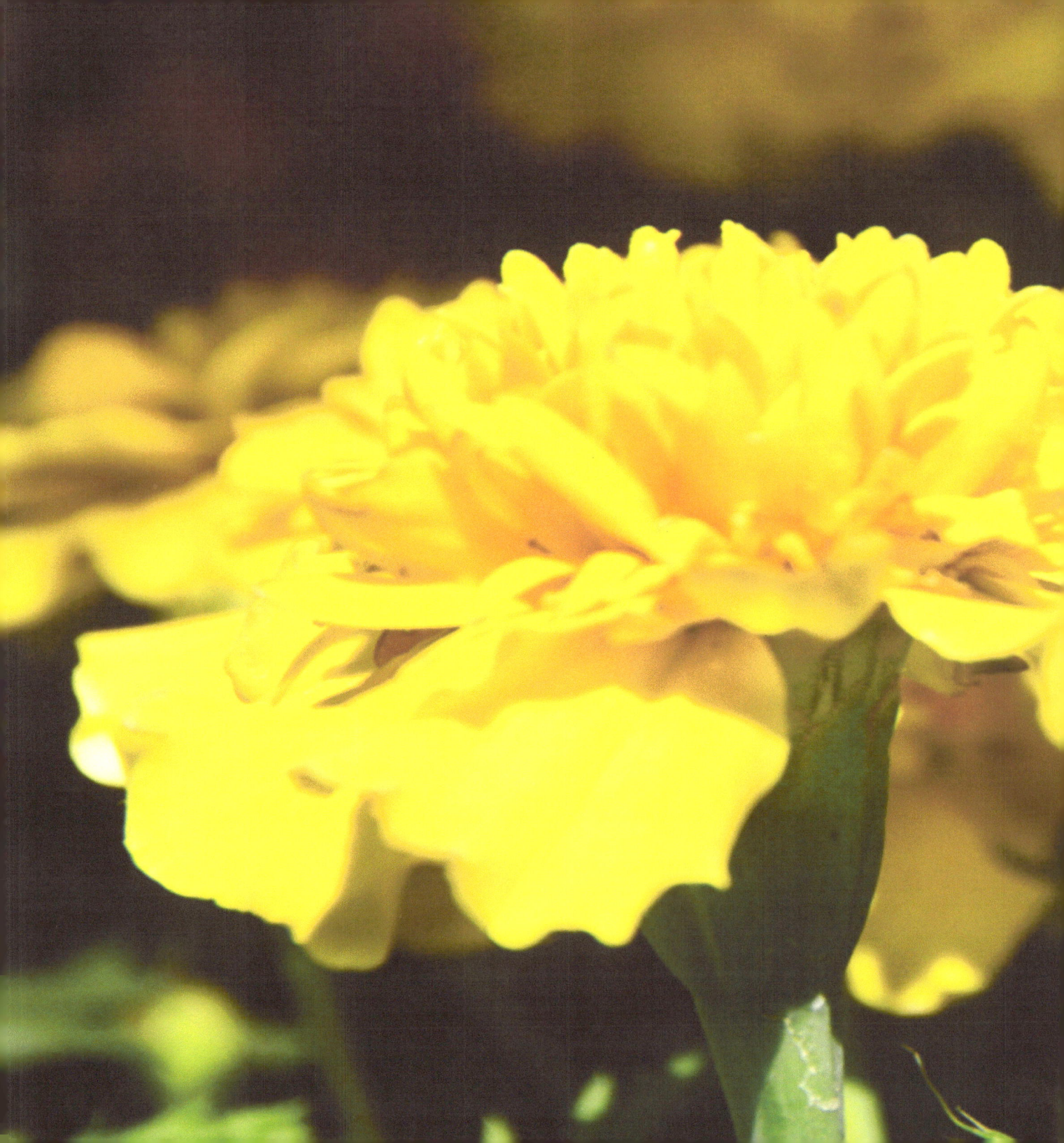

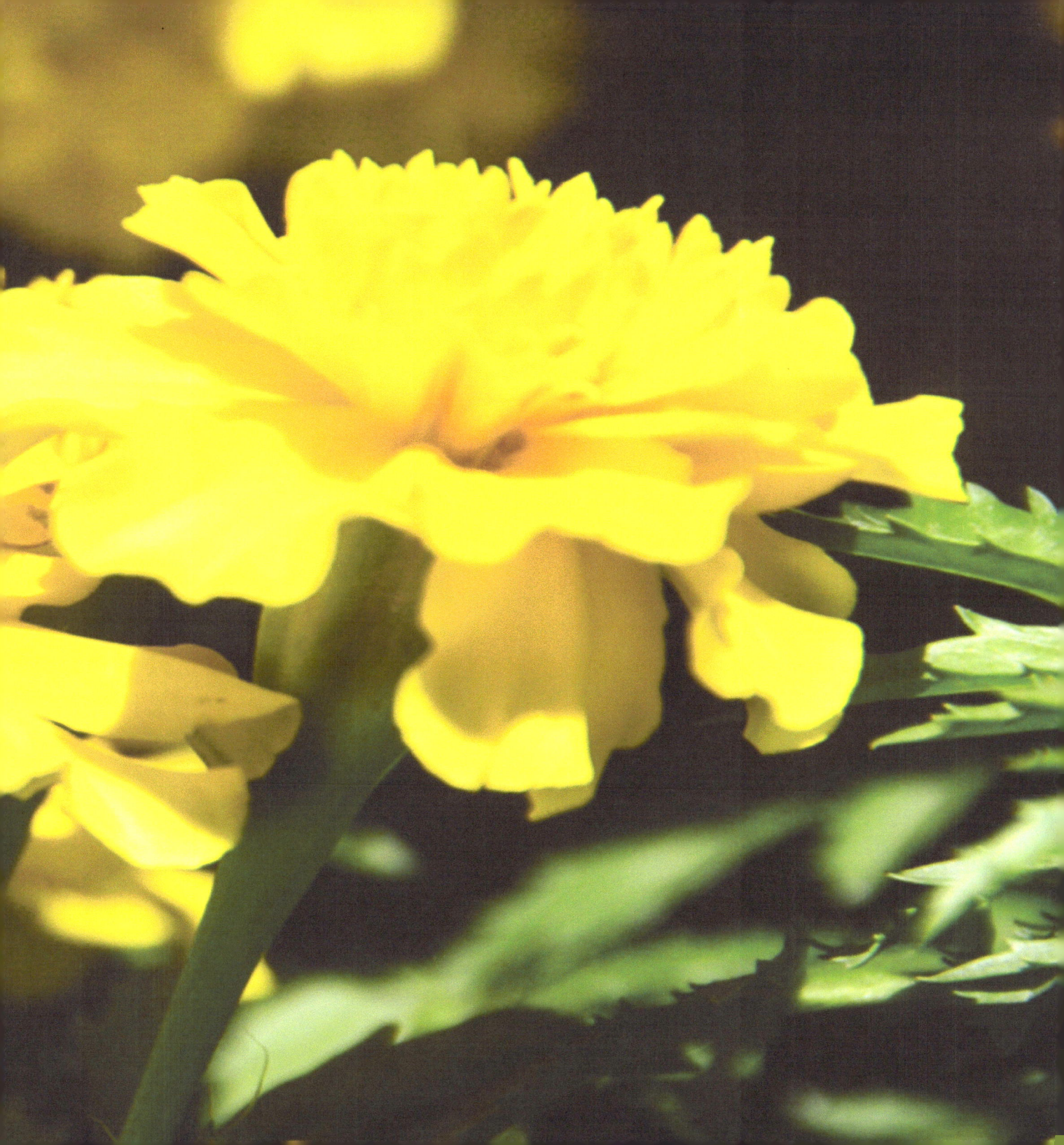

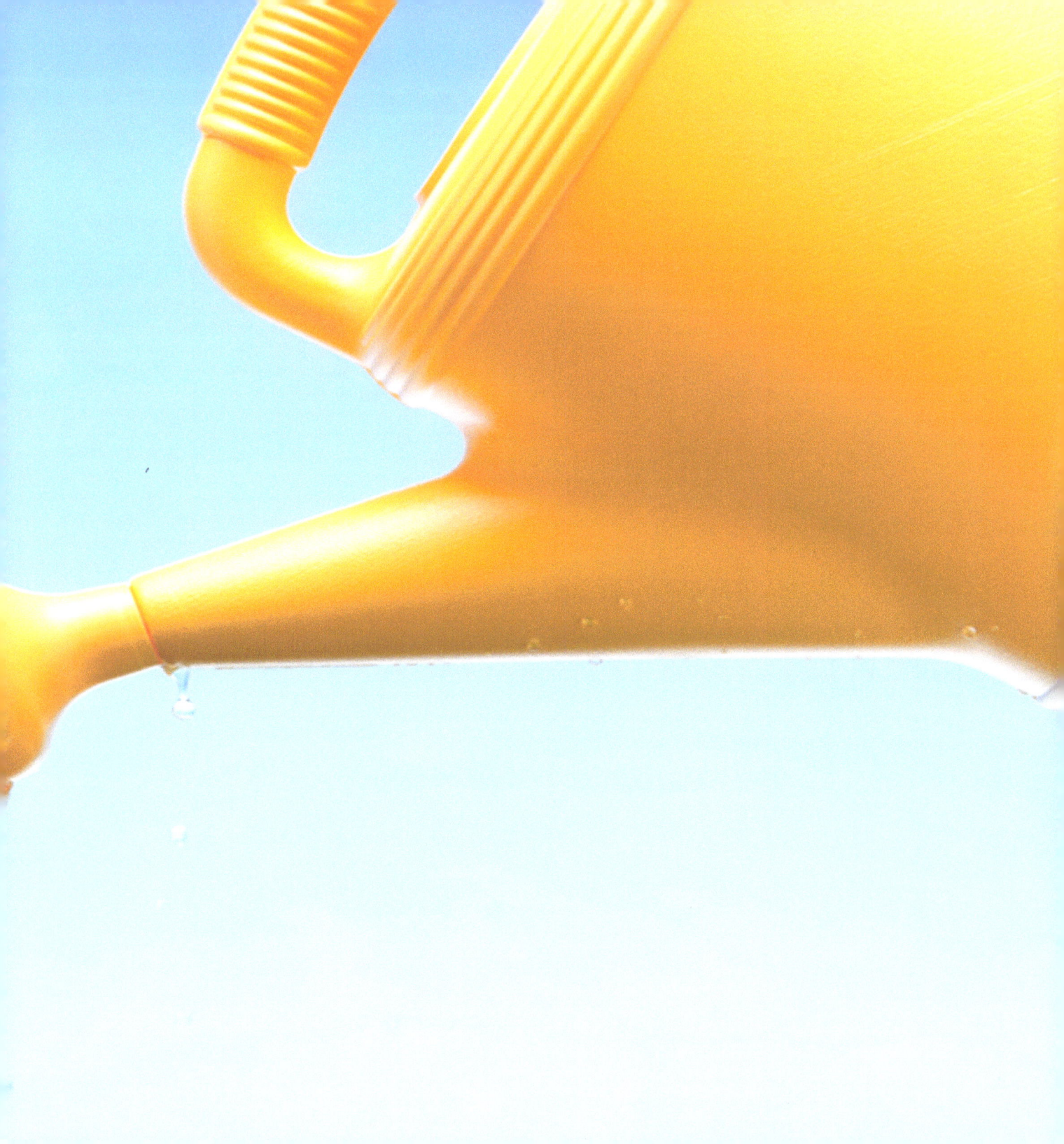

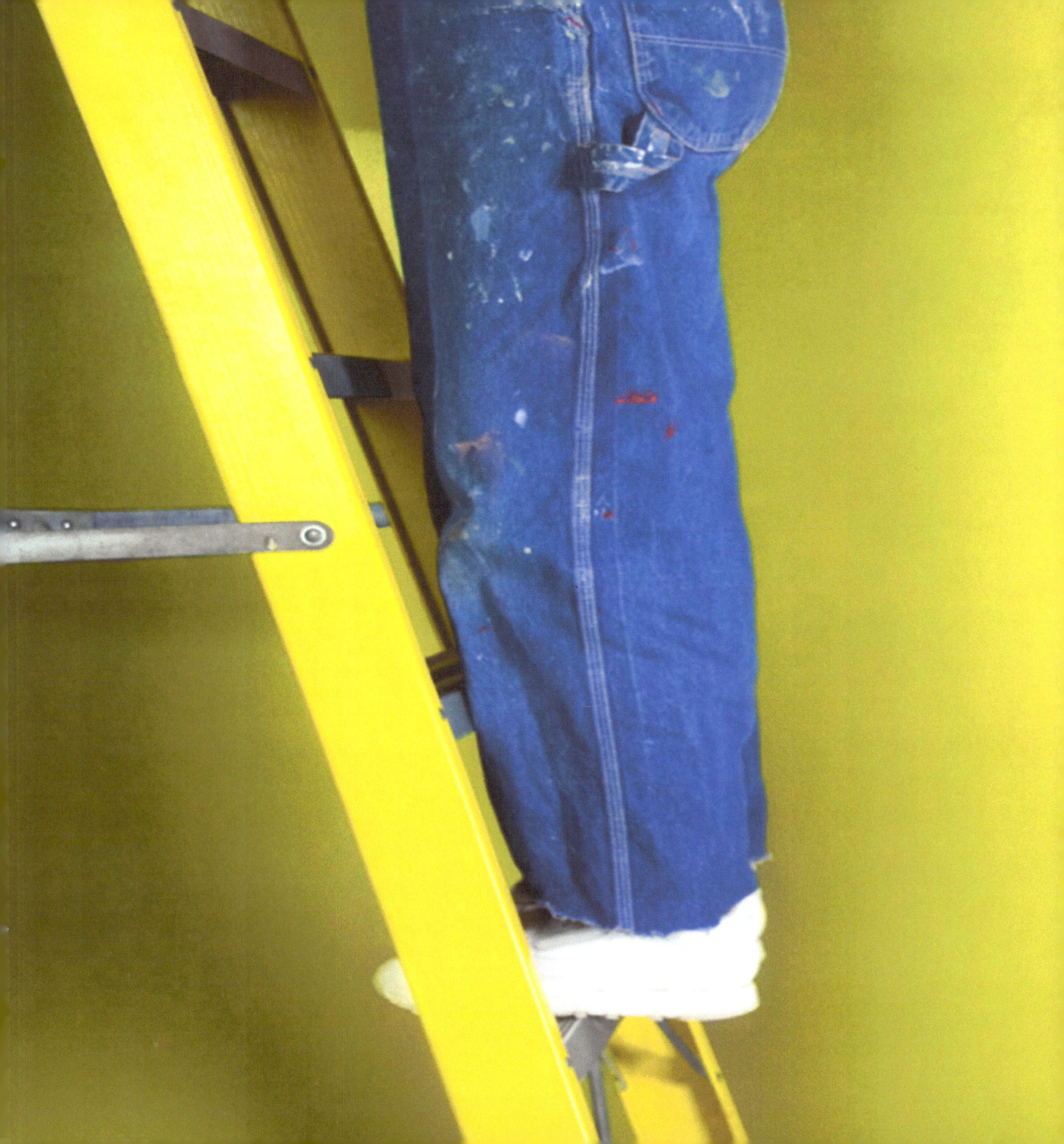

Rot

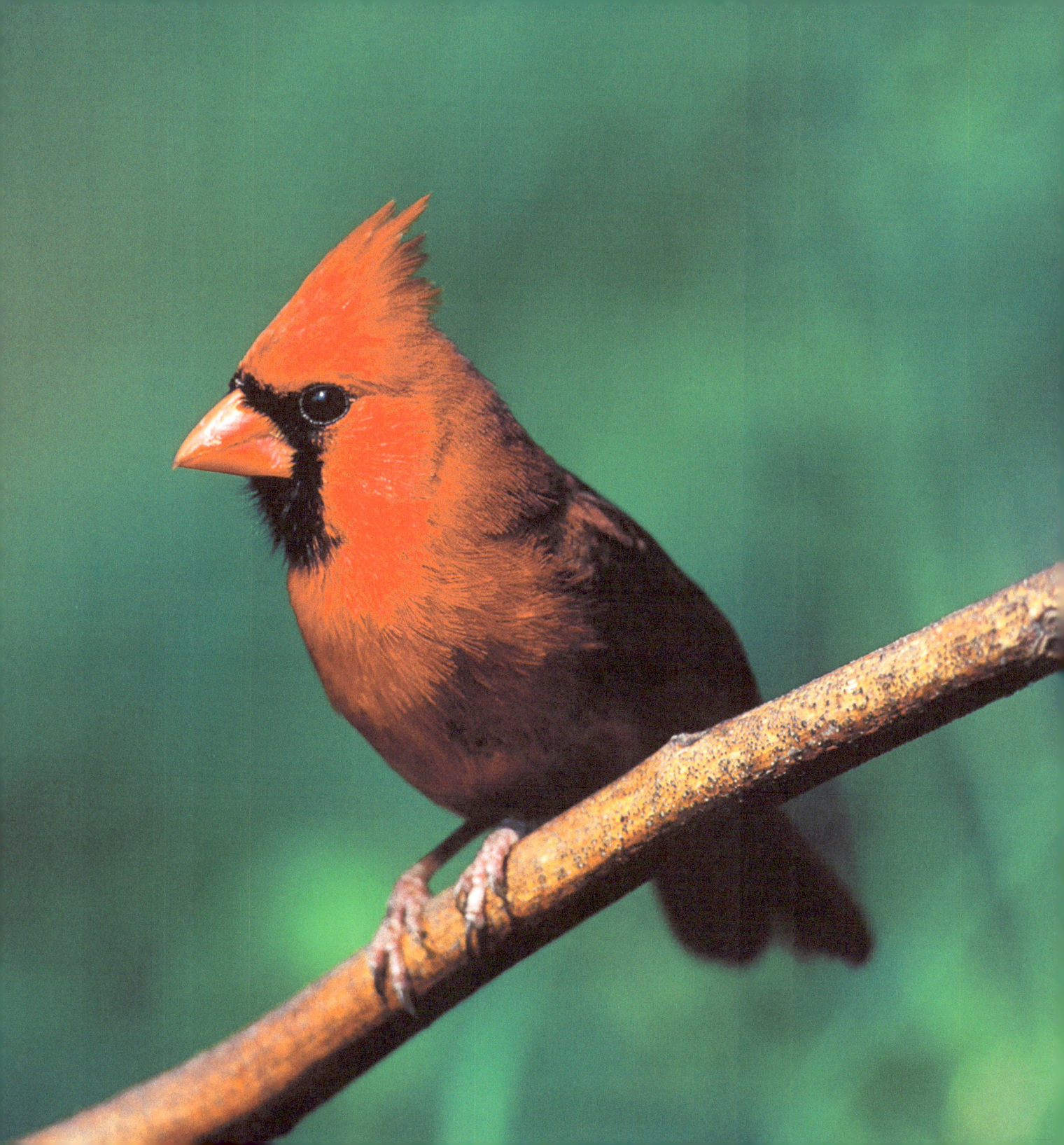

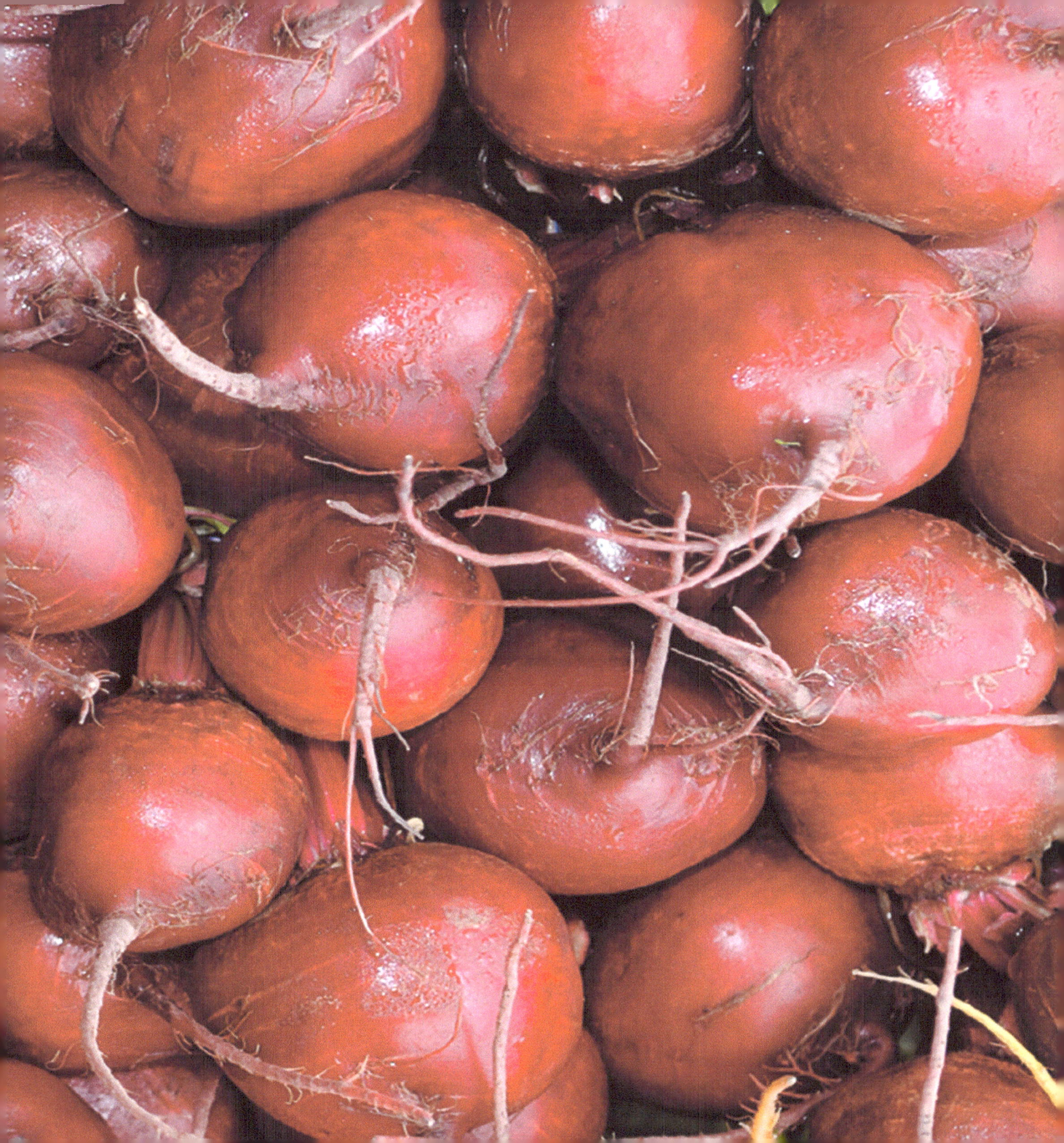

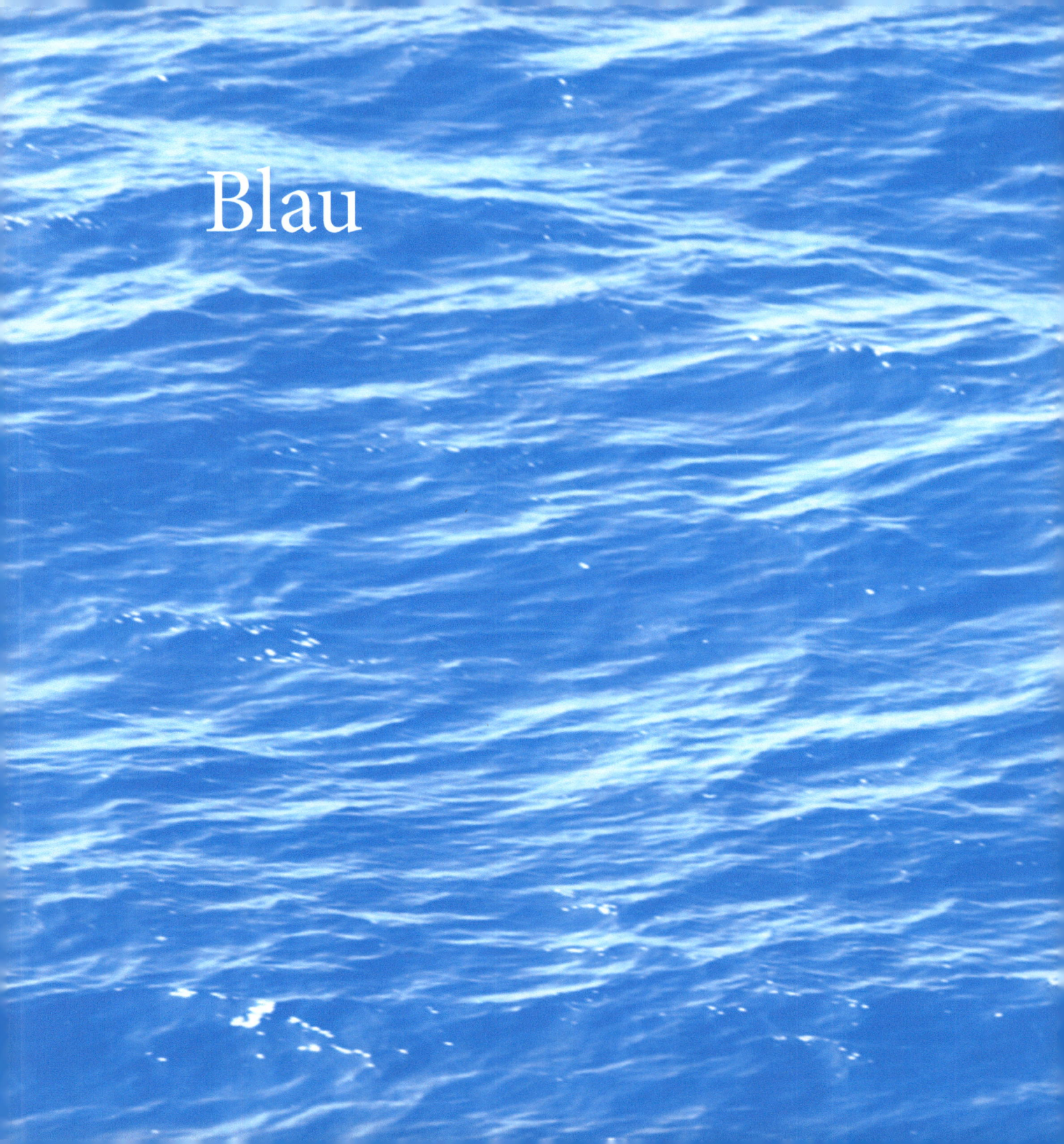

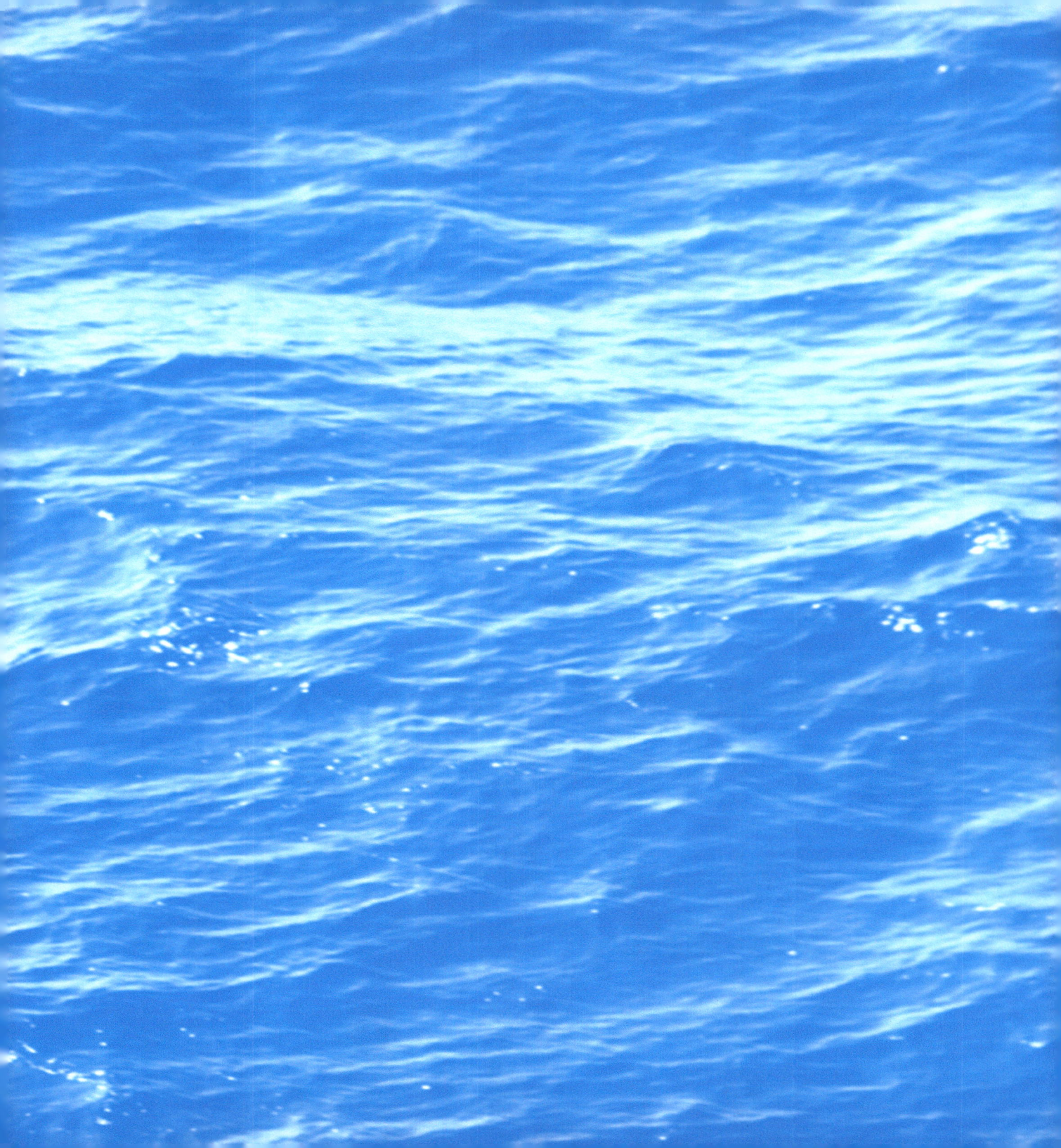

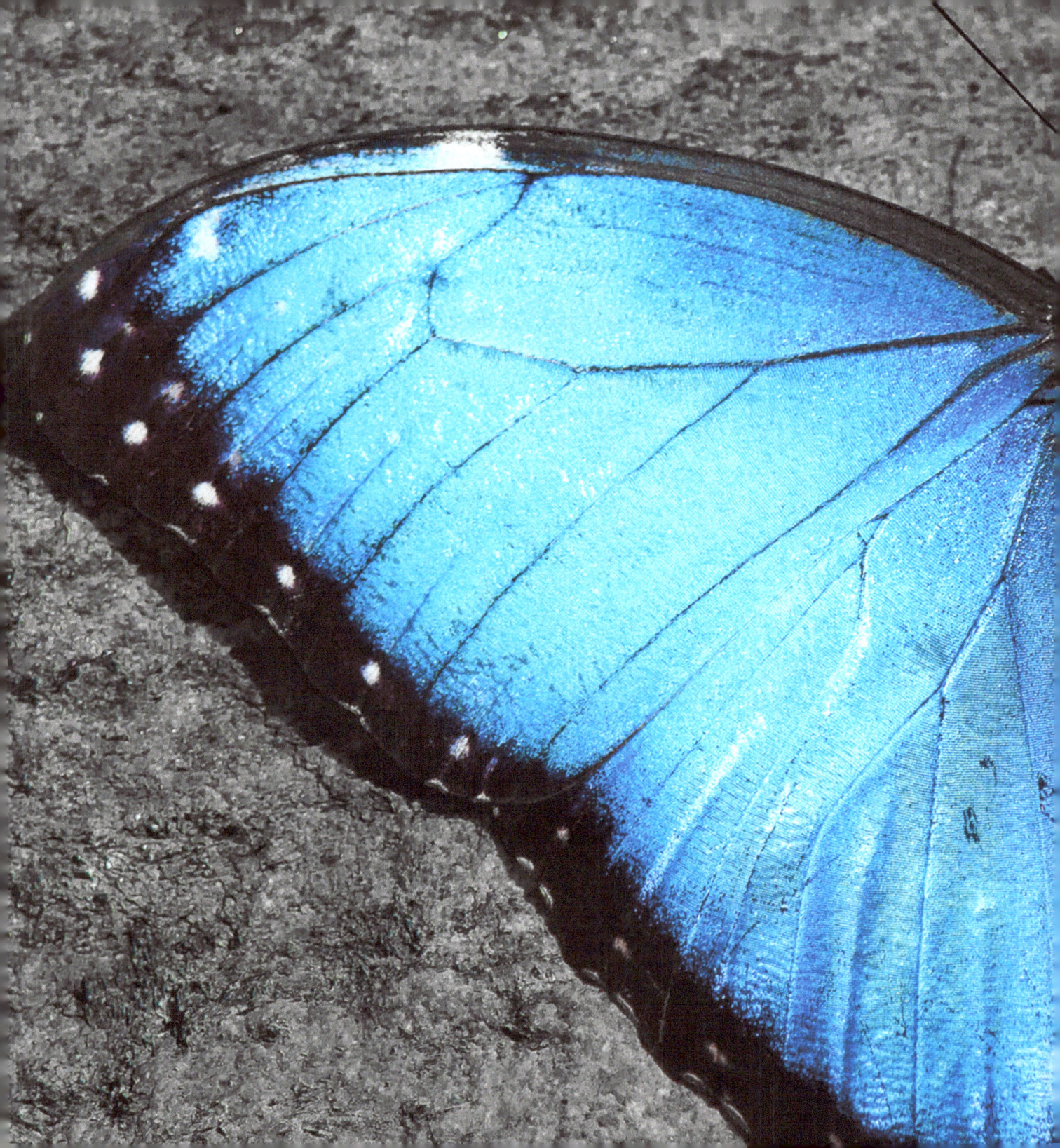

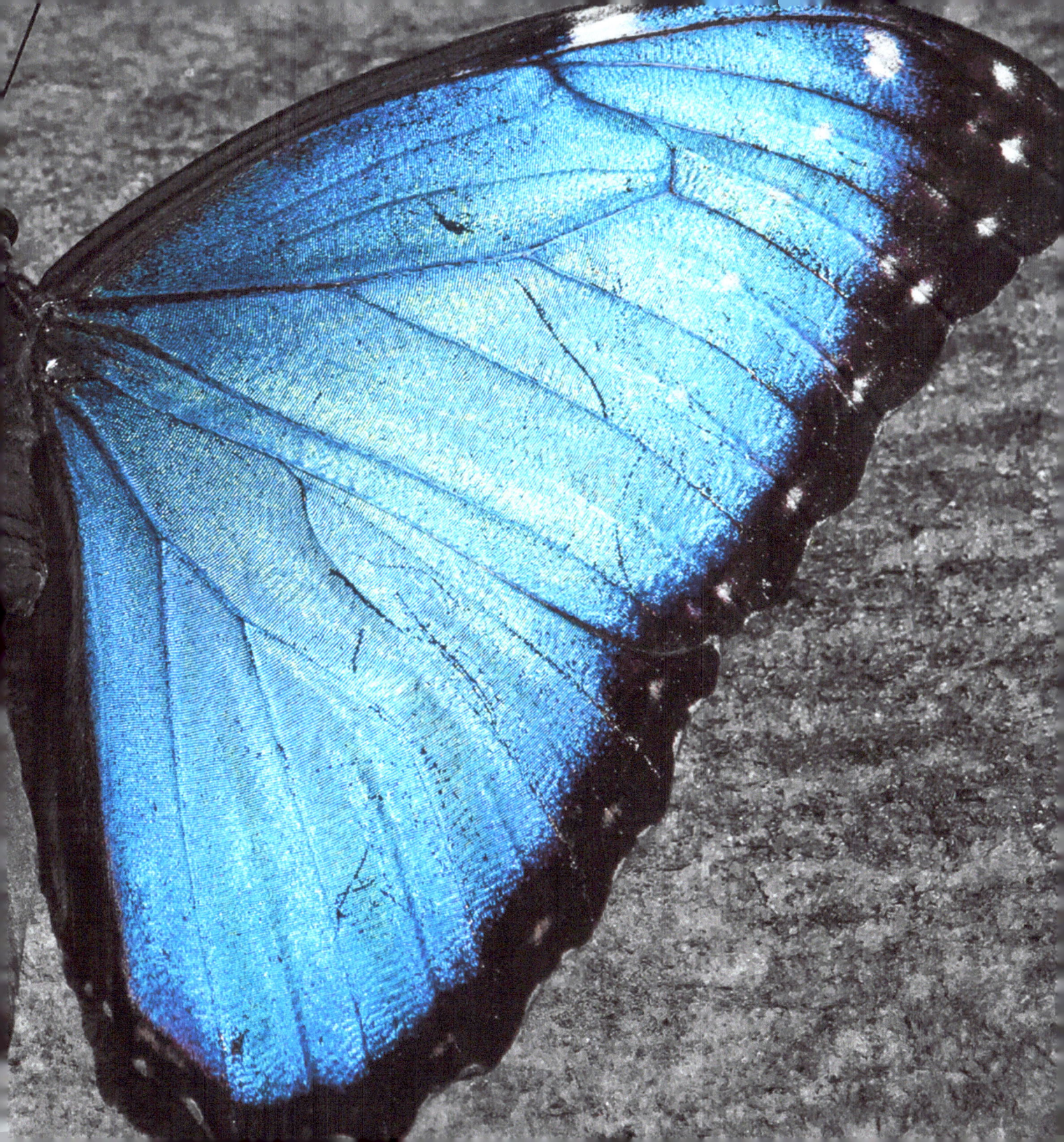

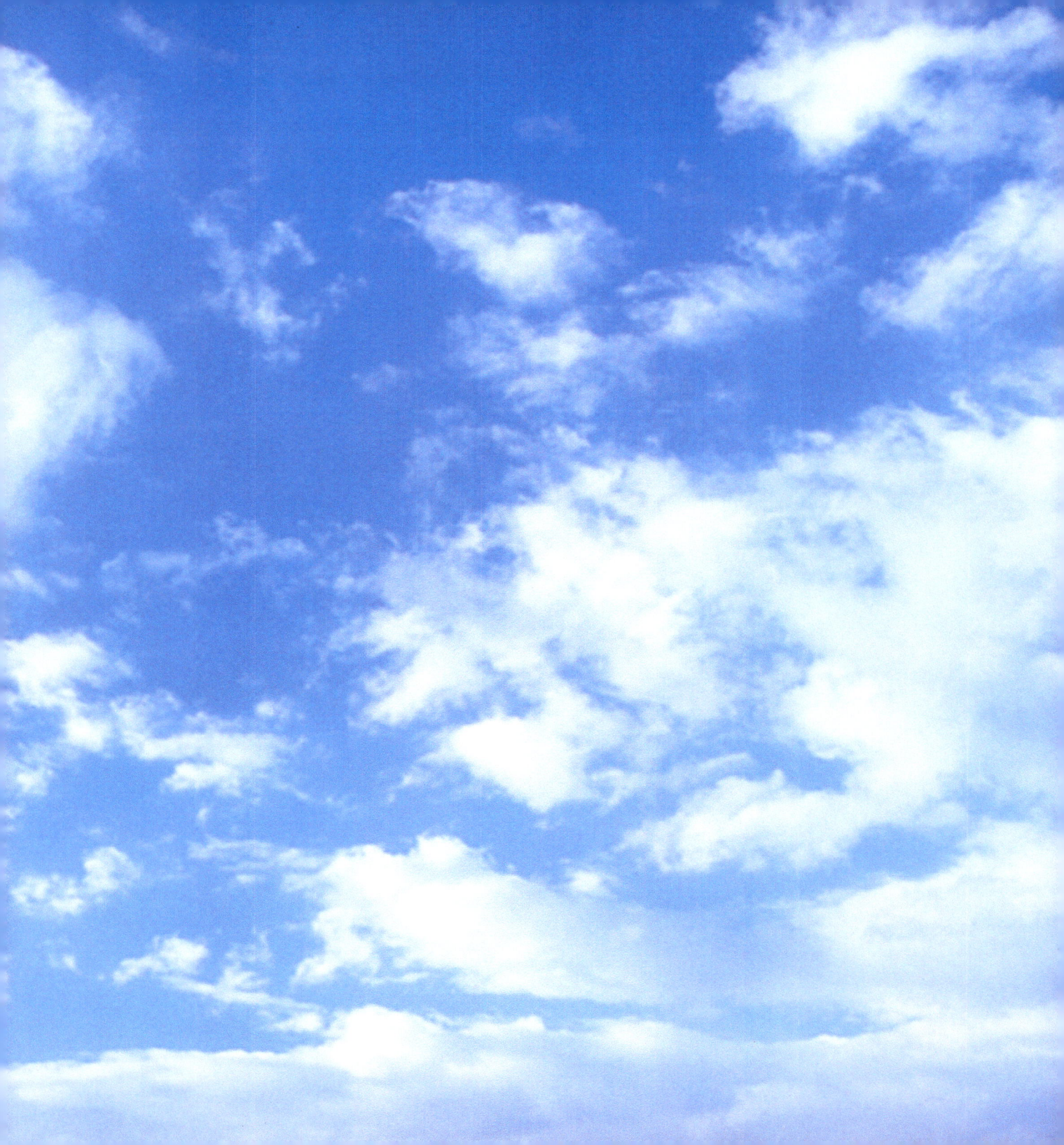

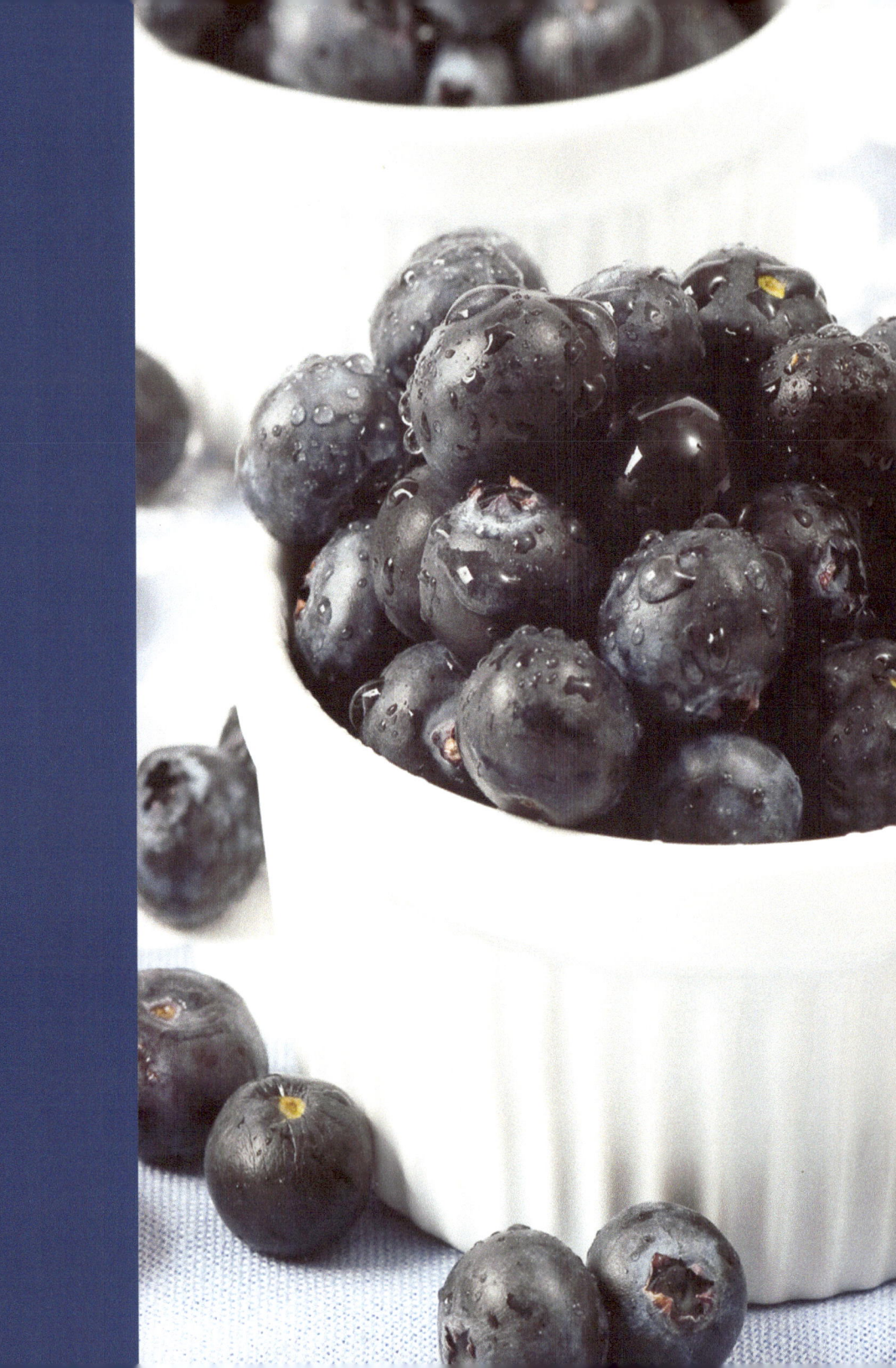

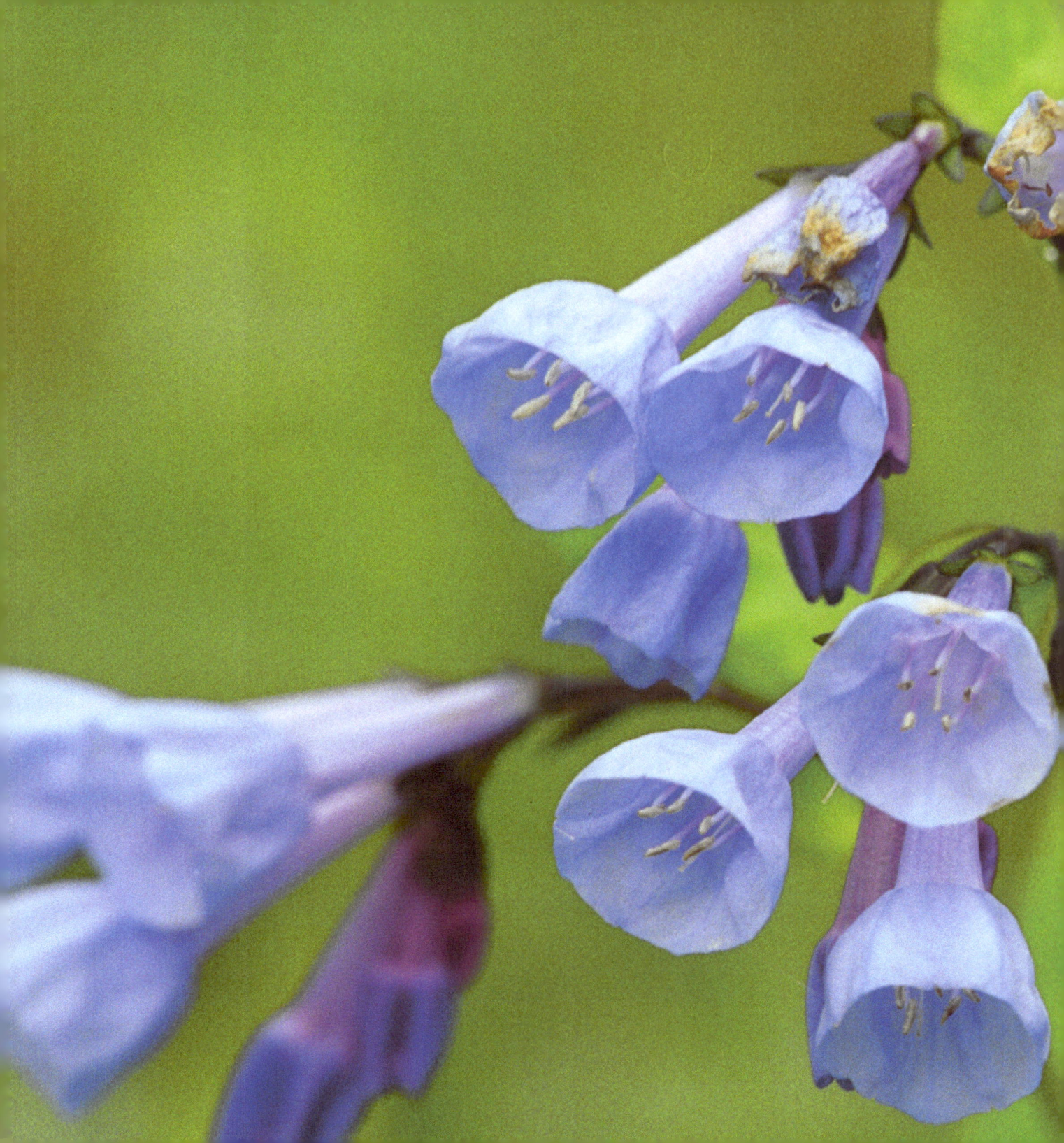

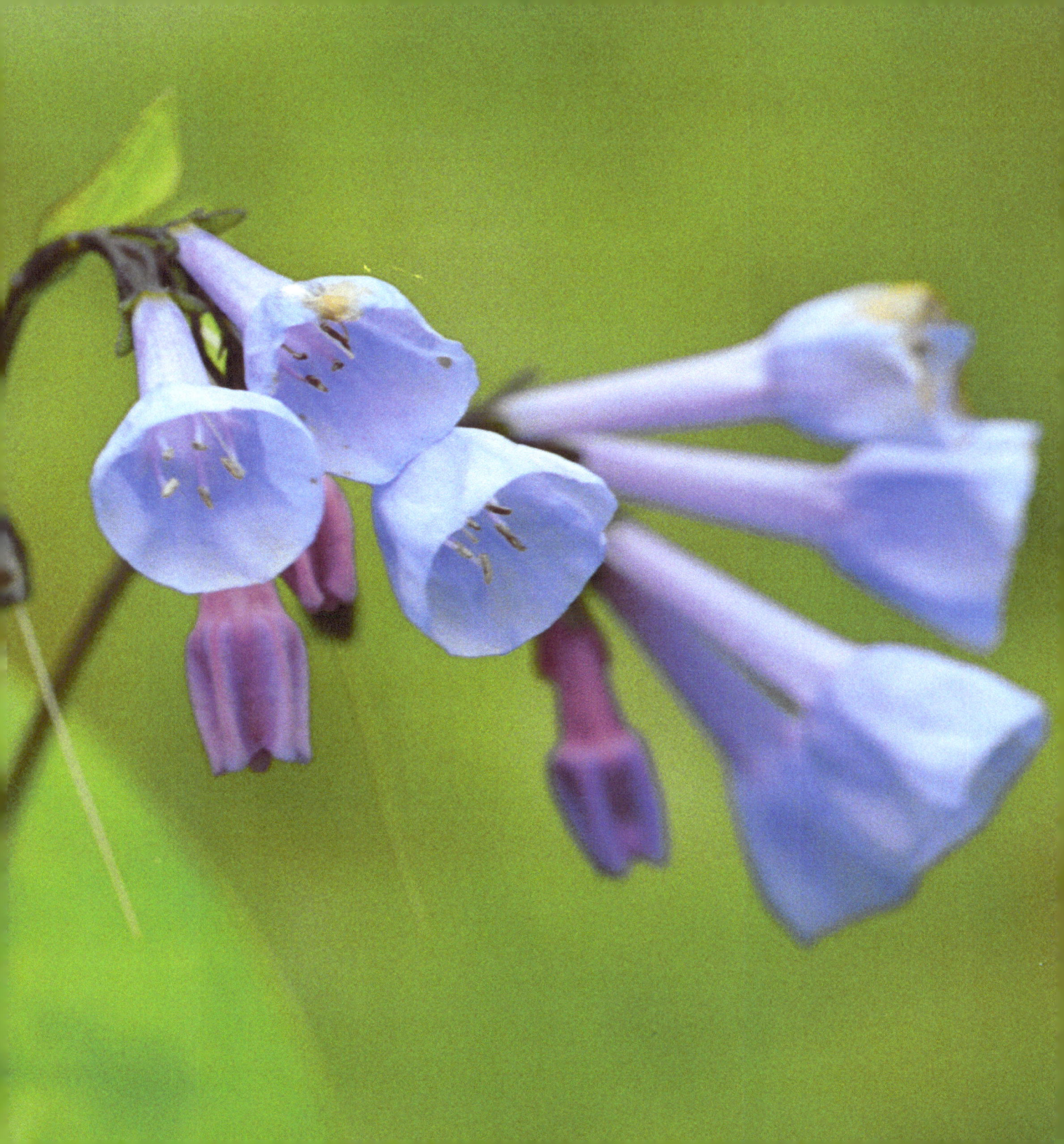

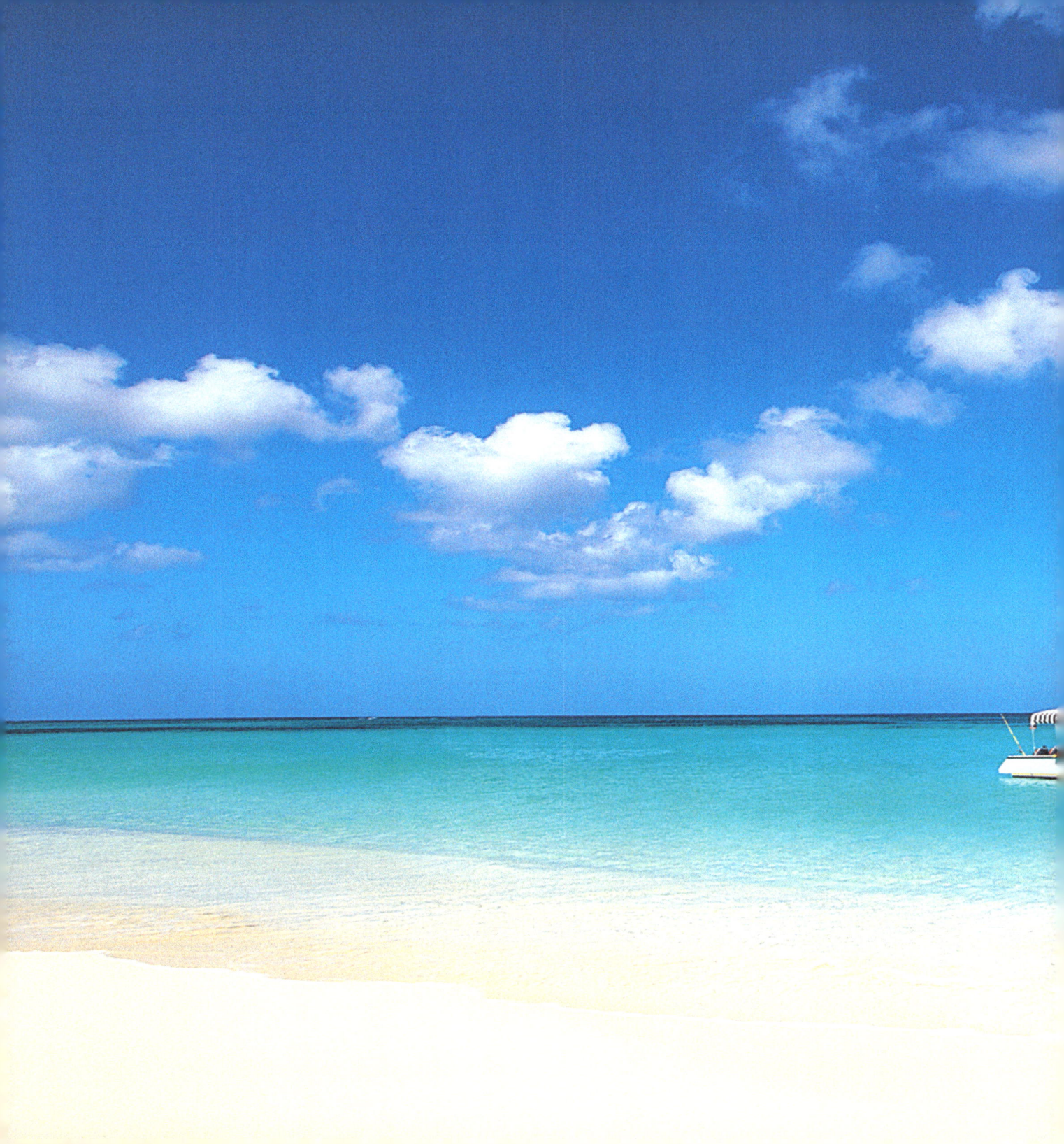

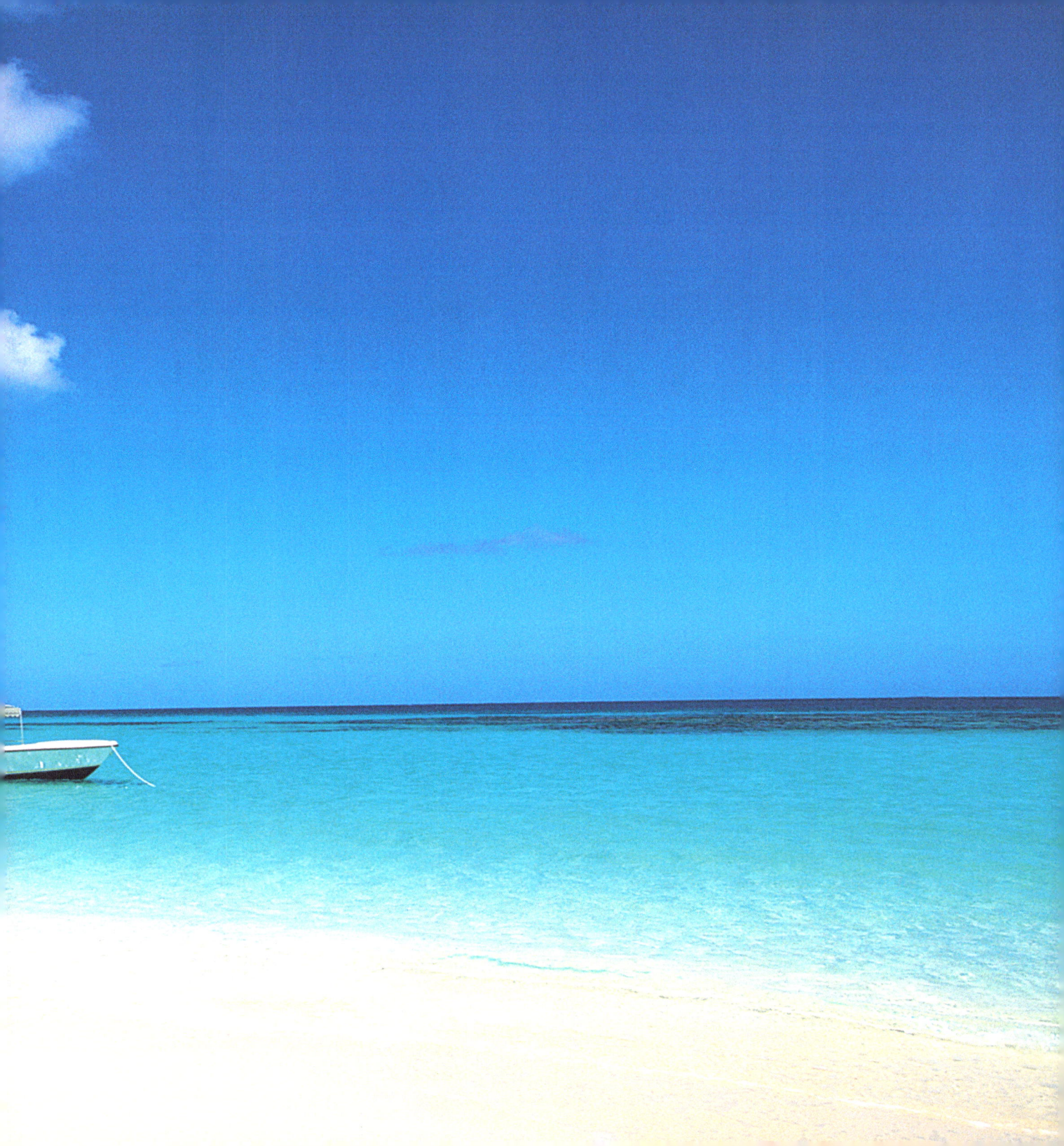

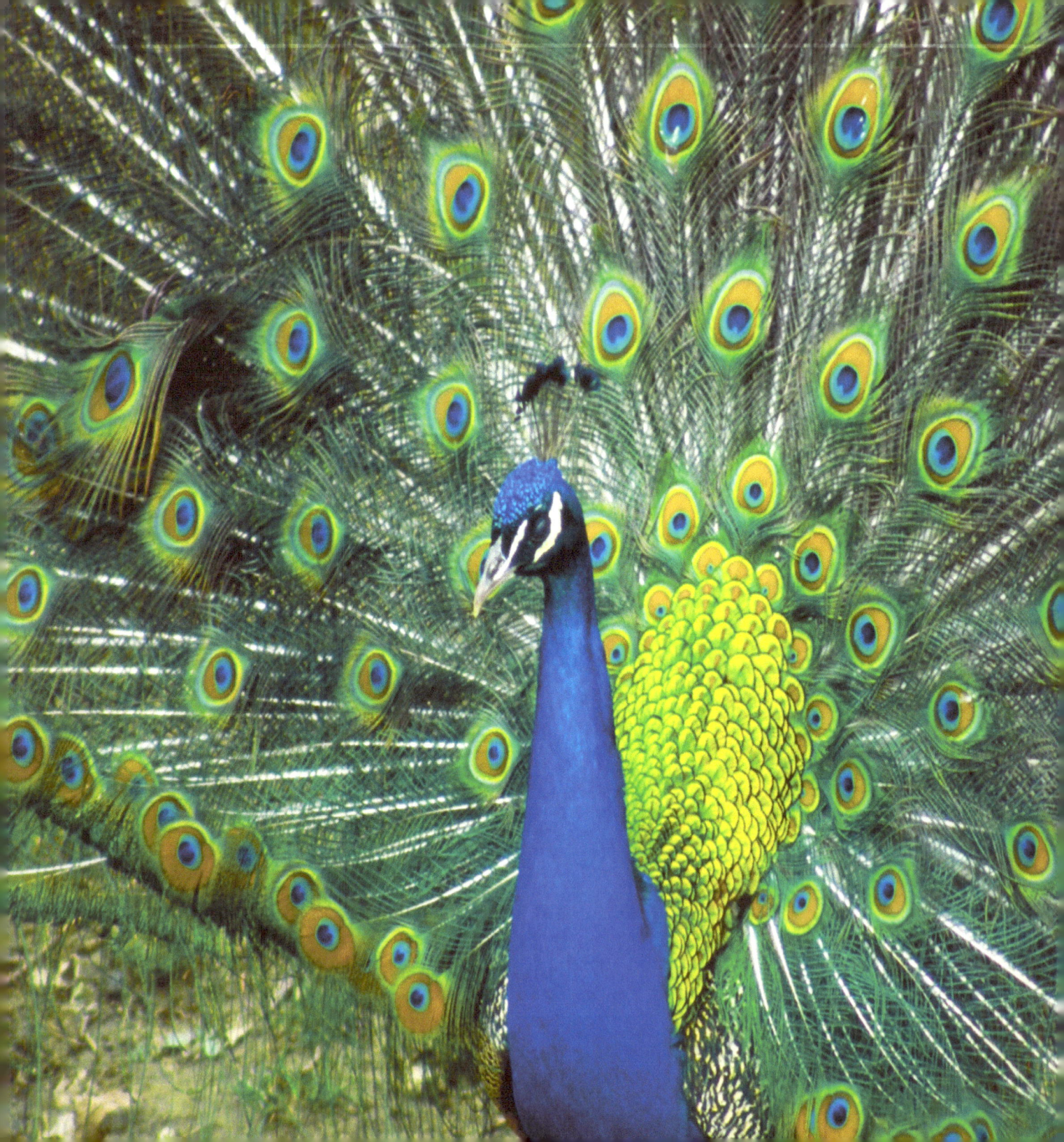

www.ingramcontent.com/pod-product-compliance
Lightning Source LLC
Chambersburg PA
CBHW050905180526
45159CB00007B/2792